A DETAILED GUIDE IN BUILDING A SUCCESSFUL PHOTOGRAPHY BUSINESS ONLINE

LEARN HOW TO MARKET, SELL, PROMOTE AND MAKE MONEY AS A PHOTOGRAPHER

By Smart Reads

Free Audiobook

As a thank you for being a Smart Reader you can choose 2 FREE audiobooks from audible.com. Simply sign up for free by visiting www.audibletrial.com/Travis to get your books.

Visit:
www.smartreads.co/freebooks
to receive Smart Reads books for FREE

Check us out on Instagram:
www.instagram.com/smart_readers
@smart_readers

ABOUT SMARTREADS

Choose Smart Reads and get smart every time. Smart Reads sorts through all the best content and condenses the most helpful information into easily digestible chunks.

We design our books to be short, easy to read and highly informative. Leaving you with maximum understanding in the least amount of time.

Smart Reads aims to accelerate the spread of quality information so we've taken the copyright off everything we publish and donate our material directly to the public domain. You can read our uncopyright below.

We believe in paying it forward and donate 5% of our net sales to Pencils of Promise to build schools, train teachers and support child education.

To limit our footprint and restore forests around the globe we are planting a tree for every 10 hardcover books we sell.

Thanks for choosing Smart Reads and helping us help the planet.

Sincerely,

Travis & the Smart Reads Team

Uncopyright 2017 by Smart Reads. No rights reserved worldwide. Any part of this publication may be reproduced or transmitted in any form without the prior written consent of the publisher.

Disclaimer: The publisher and author make no representations or warranties with respect to the accuracy or completeness of these contents and disclaim all warranties for a particular purpose. The author or publisher is not responsible for how you use this information. The fact that an individual or organization is referred to in this document as a citation or source of information does not imply that the author or publisher endorses the information that the individual or organization provided.
.

TABLE OF CONTENTS

Introduction	2
Chapter 1: Thinking Like A Business Owners	4
Chapter 2: Selling Your Work At A Gallery	12
Chapter 3: Get Online	16
Chapter 4: Third Party Websites	23
Chapter 5: Other Ideas for Getting Exposure	26
Chapter 6: What Should You Sell?	36
Chapter 7: Making More Money	40
Chapter 8: What Not To Do	42
Conclusion	50
Smart Reads Vision	53

INTRODUCTION

Art has always been a valuable part of society. Whether in the form of the cave drawings of prehistoric man, or the exquisite poetry of Emily Dickenson, art is an integral part of society. People yearn to express themselves and try to understand others through their means of self-expression. A beautiful painting or photograph can evoke strong emotions in both the artist and the person viewing the work.

Society today longs to surround itself with beautiful things and, thanks to modern technology, this is easier than ever before. As a photographer, there has never been a better time for you to strike out on your own. You can now make a living doing what you love because there is a demand for talent. And with the Internet, you have the opportunity to reach hundreds of thousands of people anytime and anywhere.

The very tool that can act as a springboard for your career can also be a major obstacle for you if used incorrectly. There are literally millions of people who are competing for attention of viewers online. Making a name for yourself means cutting through all the competition and establishing yourself, your brand and your identity. Many photographers feel that all they

have to do is to set up a website or online store and wait for the money to start rolling in. However, it's not that simple.

But there is good news, if you are willing to put in the effort, you will be able to make a full-time income from your photography. Commit yourself to building your personal brand and putting in the time and effort and you will have advantage over 90% of your competition.

This book is going to help you to learn how to start establishing your own brand and market yourself so you can make a full time income with photography. You'll learn the basics of getting started online with your own website. You'll also find out ways to sell your work and what type of work sells best.

There are also general tips on increasing your photography income and what mistakes to watch out for. Once you're done, you'll be thinking like a professional photographer.

CHAPTER 1: THINKING LIKE A BUSINESS OWNER

There is an idea out there that artists need to "stay true" to their art. If they don't, they are classed as sellouts. This is nonsense – do you know what the difference is between a "true artist" and a "sellout"? The "sellout" can actually make a good living. The "sellout" has more opportunities to create "real" art because they don't have to get a job.

Start out looking at this as a business venture. The work that you put out must be geared to what the market wants to buy. Vincent Van Gogh was a genius. He also died penniless because he was years ahead of his time. Those gorgeous artsy shots that you take are only going to appeal to a limited number of people. And until you make a name for yourself, the general market won't see value in them.

It's a sad fact in the art world. Your work is only as valuable as it is perceived to be.
If you are only photographing what you like, you will likely fail.

Do Your Research
You can maximize your chances of success by doing your research upfront. Visit art galleries near your

home. Ask the owners for suggestions on what they would like to see and what sells. Most will be willing to give you tips on this. Take time to look at what the current trends are in décor. Buyers tend to follow trends. If you want to sell your work in galleries, you will need to keep up with trends or at least consider them.

You can also think outside the box. Who needs to have photographs taken in your area? Could you pair with an estate agent, for example? Sure, taking pictures of houses for sale might be boring but it can bring in the money. It also helps you establish credibility. Maybe you could take portraits or candid shots in the park. Be willing to try new things, even if they don't seem to be what you want right now. You might not want to take pictures of Aunt Mollie's poodle, but it could turn out to be a good learning experience. You also don't know who might see the photo.

Be Disciplined
One of the hardest things about working for someone else is that you get told what to do. Your boss is on your back all the time. Ditching your boss could turn into a nightmare for you. Working from home means making your own decisions. It also means that there is no one to nag you to take new photos or update your website. You need to be extremely disciplined when

working for yourself. You can't just do what you like. There are going to be times when you need to do boring paperwork, or do promotions for your site. Working for yourself can be hard. You need to find the motivation every day to do both the tasks you like and those you don't.

A friend of mine, for example, is a professional photographer. He works from home and is extremely good at photography. He takes the most brilliant photos. He also hates marketing himself. He believes that a Facebook page is a complete waste of time. He believes that word of mouth is ample advertising. He doesn't even have an email database of his clients because he hates marketing so much. He keeps saying he will "get there" one day but never does. He manages to make a living with his photography but not a great one. He doesn't have the money to go on a holiday, for instance.

Now, if he would just force himself to sit down once a week to work on his Facebook page or email marketing, he could do a lot better. You'll need discipline for when things are going well and for times when they are not. It's easy to be motivated when everyone wants you to work for them. It's not as easy when things are going more slowly. You need to

honestly ask yourself if you have the discipline to run your own business.

This is Your Business

There is a vast difference between hobby photography and photography as a business. Taking a picture of your friend's kids might be fun now. What is it going to be like if you need to take pictures of 10 or more kids a day? You are going to need to start looking at what photographs you would like to take. Will they sell? Are they marketable? What more, you are not going to be able to spend all your time taking photos. You are going to have to do paperwork, research and marketing as well.

This can take some of the passion out from you. It can make things boring. There are going to be days when you wouldn't want to face the work. If you are prepared for this upfront, you can deal with it more easily.

You Need Thick Skin

Putting your photographs out there also means having your work critiqued, whether by professionals, clients or just anybody who feels like commenting. You need to be prepared of both helpful and not so helpful criticisms and frankly, sometimes; these can be tough to hear.

However, once you learn to be objective about the criticism and actually apply the ones that make sense then it's almost a guarantee that you and your work will improve dramatically.

Showing work at a gallery is also hard. Some galleries prefer certain subjects and your portfolio might not be suitable for what they are known for. You can either take a cue from the owner or shoot more photos with the subject they have in mind or you can ask for a recommendation if they know anyone who might showcase your work. Don't take offense if a gallery says no to your work. Find a way for you to improve or treat what they have to say as business advice. Then come back with work that's more suitable with what they're offering. You also have to take the criticisms they give professionally. If you get defensive when criticism is leveled at you, you will be viewed as unprofessional. Clients will write you off. Gallery owners will as well because they will see you as unwilling to learn.

You need to view each criticism as a learning experience. Even if what you are learning is that people can be unfair. Learn to leave your personal emotions out of it and you will be far more successful. Sometimes people will give constructive criticism you

can use. Sometimes they are just mean. You need to accept this when you are dealing with the public.

Ask for Honest Feedback
Do not be afraid to ask for feedback. Other people are more likely to view your work more objectively. You might feel that your strengths lie in one area only to find that others see it differently. As a photographer, it can be difficult to find fault in every photo you take. Getting a second opinion can be a great help. Make it easy for clients to leave feedback and ask them for it. Get advice from other professionals. Ask people what they are looking for. Most people are flattered when asked for their opinion and won't mind giving them. If you tell them that you want to improve, they are more likely to be honest with you.

Also, be as thankful for criticisms as you are with praise. It might not feel as good, but it can be a lot more helpful. The show, "America's Got Talent" is a good analogy for criticism. There are always people who seem oblivious to the fact they have no talent. They always tell the judges that their family and friends have encouraged them to pursue singing. It's a wonder how different things would have been if they had asked for honest feedback.

Surveys are Great

Quick surveys are a great way to get feedback. You can sign up for a service like SurveyMonkey to set up surveys that are quick and inexpensive. You can mail these to your database from time to time. You could post pictures on your website or blog and ask for opinions. You could run a competition on Facebook asking people to choose their favorites. You could also have a quick survey card that people can complete when viewing your work in person. There are many different options but only two rules. Make it as easy as possible for the client and do not harass them.
Emailing your clients surveys every day or even every week is going to become a nuisance. Harassing people to fill out a survey card can put them off. Make it fun and easy for them. Keep the answers short and simple. Have multiple-choice answers with space for further comments. And don't do these surveys all the time. Perhaps you could have a "Photo of the Month" competition as a way of gauging interest in your work, for example.

Be Prepared to Put Earnings Back into the Business
So, you've sold your first batch of photos and you have some money to burn. Not so fast. You need to keep putting money back into the business so that you are able to keep up your marketing or buy new equipment, etc. You should work to build up a reserve

fund for those months when business will not be doing so well.

CHAPTER 2: SELLING YOUR WORK AT A GALLERY

Selling your work at a gallery can be lucrative. People going into a gallery are normally looking to buy a piece of art and so they could be the exact market you need. You need to understand a few things first though.

Choose the Right Gallery
You need to find a gallery that will be a great fit with your style of photography. You also need to be able to get on with the owner. Visit the gallery ahead of time to get an overall idea of their style. Visit again in a few weeks to see what kind of turnover there has been. You do not want your work to sit idle in a gallery for months. Research them. How do they promote their gallery? How do they promote the artists that they represent? What is their reputation? How well established are they?

Getting In
Once you have chosen a gallery, you need to convince the owner to display your work. In the more established galleries, this could be difficult. You may not be successful.

Research the gallery and make an appointment to see the owner and take samples of your best work. Make

sure that it is professionally presented. Consider how the gallery sells their photographs. Package at least one accordingly. Before taking your work out, ask them what they are looking for. Ask them what you need to do to get them to consider displaying your work and listen to what the owner says. A good businessperson will know what kind of work they want on display because they know what sells. If you want them to display your work, you'll need to fit in with what they want.

The fact that you are starting out is not as much of a problem as you might think. If the gallery owner can see that you are willing to take advice and be professional, they will be more than willing to work with you. Present only your best work and be sure to do whatever you promise.

You Normally Bear the Costs
In most cases, the gallery owner is going to expect you to present the work upfront on consignment. You will, more than likely, need to pay for it to be framed or, at least, put behind a mat. Packaging your work professionally not only protects it but makes it more likely to sell. It is a capital outlay but you should be able to recoup your costs once your piece sells.
Understand Your Responsibilities

You are also going to be expected to market your work. The owner might expect you to be present at openings, etc. in order to meet clients. You might be expected to produce a certain number of pieces. It is important that you understand upfront what the owner expects of you so that the relationship works well.

What is the Commission Arrangement?
Galleries are a business. They have expenses like any other business. And, like any other business, they only get paid if stock sells. They also generally charge high commissions on sales. They are essentially renting you a bit of space in their gallery.
Expect to pay anywhere from 30% upwards in commissions and work it into your pricing. Always get a proper contract drawn up before you start providing work.

What happens if work that is in the gallery is sold on your website? (The gallery will usually expect their cut.) Does the owner expect you to be exclusive? What will you charge clients who approach you directly? Whilst your overheads are not going to be as high as the galleries, undercutting them can be a bad move. Whilst it might help you sell more, it can damage your relationship with the gallery. This all needs to be

hammered out in advance so that there are no arguments at a later stage.

Starting Your Own Gallery
This is not an option for the faint of heart. You need to have a decent amount of capital set aside ahead of time.
A new business is not likely to start showing a profit for at least a year and you need to be prepared for this. You will either need to be a good businessperson or employ someone that is. It's best to work towards having your own brick and mortar gallery only after you have an established name. For those starting out, while not impossible, this is a risky option.

CHAPTER 3: GET ONLINE

Online is the way of the future. It gives you access to the greatest pool of clients and is a relatively inexpensive way to go. It will still be hard work though. You can set up a website in minutes but getting people to visit it is going to require some effort.

Statistics show that the average web surfer takes just 6 seconds to decide whether or not to stay on a site or not. You are going to need to convince potential customers to stay and have a look. You will also need to convince them that your site is a credible one.

Getting Your Own Domain
When it comes to your own website, you need a domain. This is basically an address for your site. There are two basic options when it comes to a domain – a free domain and a paid domain. The problem with the free domain is that it will usually have the name of the site you got it from in the actual address. For example, photography.wordpress.com. This straightaway gives the impression that you are unprofessional. And why should people trust you with their money if you won't even pay for a custom domain? Hence, it's advisable to secure a professional custom domain.

Hosting Your Domain

If your website is like your address, the host is like a landlord. The domain fee is an annual fee that you pay for the name of the site. Meanwhile, the hosting fee is basically rent for the space your site occupies. Your website needs to be hosted on the host company's servers. Plans range starting at about $5 a month, depending on how much space is allowed and how many features are added. You can usually save money by taking out an annual plan.

You cannot skimp here at all. You will need a site that is capable of hosting a number of digital images. If you plan to sell photos from your site, you will need to be able to add a shopping cart as well. The cheapest plans will not allow you to do this.

Other Things to Consider

You may also need to pay for your site to be encrypted. This is usually an annual fee. Whilst encryption is not something that you must have, it is preferred because it protects the information on your site from hackers. This is imperative if you are going to have people pay using their credit cards. It has also become more important to how your site shows up in search engine listings. Google now marks unencrypted

sites as less credible and so they do not feature in search results.

Worse still, people who try to access your site may get a security warning that the site is not secure before they go to it. Now, if a screen popped up warning you that your information may not be secure if you visited a certain site, would you be comfortable buying things from it? Would you even continue on to the site? Most hosting plans will include at least one custom email address as well. This helps to make you appear even more professional.

Your Own Website
Your site does not need to have all the bells and whistles but it does need to be fully functional. You need a site that showcases your work and makes it easy for clients to buy from you. Take a lesson from Amazon.com, one of the world's leading online businesses. They practically demolish the competition by making it super-simple for people to buy from them. Their "One-Click" option for buying only saves the consumer a few seconds but it has been extremely effective.

People are generally lazy and busy so make your site must be easy to navigate. Most people will not try to figure out where you have hidden the sales cart if they

can't see it. And they are even less likely to contact you.

What's more, the content on the site should be useful and pertinent. Give some information about who you are and what the company is about and a link to your work. You don't need pages of testimonials or trivial details about your life. Make sure that the content is free of any typos, that it is readable and that all the links work.

A Professionally Designed Site
If you are a complete newbie when it comes to web design, consider having the site professionally designed. This is an expense but one that will prove worthwhile. There are plenty of templates and web design software out there to use but a custom site is a lot better. A template that you download online could end up looking too generic and it can be difficult to make the changes that you want.

Web design is relatively simple, if you know what you are doing. If you do not, you are going to waste a lot of time and energy on something that may end up doing your business more harm than good. As much as possible, consider having a professional design your site. That way, you will get what you want from day 1 and it will work properly.

Before choosing a professional, find out whether or not they use WordPress as a base for the site. WordPress has a very user-friendly interface and this makes it easier if you need to change something later. If you rely on the designer, they will charge you for doing updates.

Google Analytics
Sign up for Google Analytics and link this to your site. You do not need to pay for this service and it is very useful when it comes to tracking visitors, bounce rates, etc.
It also gives you tips on improving your site overall. Do check the stats regularly. You can see where your visitors live, how much time they spend on the site and where they were referred from. The geographic location is important if you are focusing on local business. The amount of time spent on the site tells you whether or not people are actually responding to your site or not. Knowing where the traffic is coming from can help you streamline your marketing and SEO. The stats will also tell you if the traffic originated from Google, Facebook, etc.

A Note on Copyright
Copyright is something that works for you and other artists. It protects your intellectual property. What

this means is that not only is someone not supposed to copy your photo without permission but they also cannot copy the concept. This is good to bear in mind when taking your photos. You should never copy another photographer's work. Draw inspiration from it by all means but always put your own spin on it. Embedding a watermark into your pictures online is one way in which you can protect them from unscrupulous people who just copy and paste them.

A Note on Releases
Whenever you take a photo of a person and their face is recognizable, you need to have them sign a release form. You don't need this if you have been hired to take a portrait but only when you want to use the photo as an ad or have the image for sale as a print.

If the person is underage, you will need their guardian's permission. Strangely enough, this also applies to recognizable buildings. You will need to get a release signed by those that own or manage the building. Releases are extremely important, especially if you are offering your work for sale. On stock websites, you may even be required to upload the releases. It also applies to photos used on your website or blog. If you do not have a signed release, the person in the photo could sue you for distributing their picture.

A Note on Rights Assigned

Depending on how you are selling your work, you would assign different rights to the person buying it. If you are giving the person full rights to the work, it is officially no longer yours. They may do whatever they like with the photo. They can use it to create marketable products, resell it, etc. If you give away full rights, you may not copy the picture or sell reprints later. If someone has asked for full rights, you are entitled to charge more because you will get no further income from the work.

A person buying your work at a gallery will usually just be entitled to use the photo for personal use. If you sell it as an original, you cannot reprint it later. You can assign partial rights if you like. You could allow the reprinting of the photo on various items but still retain the right to sell more prints or downloads. Depending on the agreement, you may be entitled to royalties every time your photo is used. You should ensure that the agreement is in writing if this is the case.

On stock photo sites, you are paid every time someone downloads a photo. They will usually allow someone to buy full rights and pay you accordingly. You are not, however, paid royalties on these sites.

CHAPTER 4: THIRD-PARTY WEBSITES

These provide an alternative to setting up your own sites. These sites have the advantage that the basic admin structures are in place. They are also well-frequented and rank highly in search engine results. Your rating as a seller is very important on these sites. It is one way in which the client decides whether or not you are a trustworthy seller.

Be sure to answer questions from clients quickly and politely. Thank them for purchases made and treat them as you would like to be treated. Service here is more important than in a brick and mortar store. People cannot inspect your photos in person and so more trust is required. If you make the experience a highly pleasant one, they will return and buy more or refer others.

Just remember that bad service is always going to cost you in the long run. Someone who has experienced bad service is bound to tell as many people as they can. Online they may post on the site itself or on social media.

Selling Your Photos as Artwork
Sites like DeviantArt, CafePress and Zazzle lets you set up your own online gallery. Your photos can be sold as

prints, on canvases, on mugs, T-Shirts etc. Basically, your client will choose the photo that they like and then be able to choose what object they would like to see it on. They handle the billing and delivery as well. The site earns a commission on sales. With these sites, basic accounts are free. You can pay for better features though.

Selling Digital Downloads or Prints on Your Own
Sites such as eBay and Etsy also allow you to open your own store. You can then list your photos as digital downloads or as prints. Again, the basic accounts are free and you can pay extra for additional features. The site will handle the billing and payments. You will need to handle shipping where applicable.

Stock Photography
Stock photography sites are probably the most common method you have heard about. Sites like Shutterstock fall into this category. These sites can be a fair way to make money but you rely more on the volume of sales here. These sites do allow you to upload photographs. You get a percentage of the sales received according to the number of downloads of the photo.

These sites are quite strict when it comes to the quality of photos uploaded. You will normally need to

submit them for approval. With all of these sites, and with online sales in general, you do need to do a fair amount of marketing yourself. You also need to keep a pulse on what people are actually looking to buy.

CHAPTER 5: OTHER IDEAS FOR GETTING EXPOSURE

If you sit and wait for customers to come to you, you could end up waiting a long time. Get out there and let people see your work. Speak to local businesses and inquire about displaying your work. Think outside the box.

Perhaps you can hang a few photographs at your local doctor's office, with your name and number displayed. You could switch out the photos from time to time. What about doing some free photography for a local charity? Or donating some photos for them to raffle off or sell? Festivals and craft fairs can also be a great way to get your work out there. Look for opportunities to network whenever you are able to. Whichever method of promotion you choose, be sure that people are able to link your work to your business name and that they can contact you.

Use the opportunity to get some good feedback. Speak to people about your work. Find out what they are interested in. Have professional business cards printed and always have them on hand. You don't have to push sales all the time but you do have to always consider your brand. If you can establish a strong and trusted brand, you will have won half the battle.

Having alternative avenues will help to ensure that you have a more consistent source of income.

Competitions
Competitions can be useful when it comes to building your confidence and potentially getting some exposure. You may even win some prize money. Generally speaking, competitions are more of a way to get feedback on your work and not a primary strategy for income. You must also realize that by submitting the photo, you may be giving permission for it to be reprinted several times over. Check the terms and conditions of the competition first.

Festivals and Craft Fairs
These are good for both networking and sales. Perhaps you could also have a photo booth at the fair as well or take candid shots. Use the opportunity to network and to add people to your database. Have some photos printed up and framed. Have some printed onto canvas and block-mounted. Have others simply presented with or without a mat board. In that way, you are able to offer different price points for clients. Some clients like to buy their artwork ready to hang. For these clients, the frame will be part of the allure.

Others may want to frame the work themselves so that it fits in with their décor. For framed shots, work out a price with and without the frame, so if the customer doesn't want the frame, you can just remove it. When it comes to the packaging after a sale, make sure that you have all the supplies that you need. Make sure that you have extra plastic bags; bubble wrap and packing tape so that the work will reach the client's home safely. Always ensure that you put your name and contact details on the back of the photo or the back of the framed piece. You can also include a card in the package but attaching details to the work itself guarantees that it won't be thrown out.

Consider adding an incentive to drum up more business when packing the work. You could perhaps offer them free shipping or a discount with their first purchase on your website. And always take down their details. A follow-up email or call a few days later to check how they like it at home helps to establish a better relationship. During this follow-up, it is important not to try and sell anything at all.

Social Media and SEO
Establishing an online brand is about more than just having a website. You need to keep up to date with your clients and let them know what you are doing as well.

Blogging

Blogging can be a good way to let people know what your brand is about. It can add value to your client's lives. The key with blogging is consistency and top quality content. It's recommended to post at least once a week. Keep the posts relevant to your business and useful for your clients. Ideally you want your clients to share the posts so you get more exposure. Think of things that might interest them. Like, for example, how to care for their art, or how to look after their own cameras.

When writing a post, make sure that the work is easy to scan and read. You should have few sentences longer than 20 words. Your paragraphs should consist of two-three sentences at most.

Using these tips, with the addition of pertinent subtitles, you ensure that your text is easy to read and broken up into manageable bits. People are more likely to read it.

Photos for Your Blog

It is also important to ensure that you have at least one good quality and interesting photo for each blog post. These should ideally be taken by you. If you need help in this department, you can find some free photos on sites such as MorgueFile. (You will need to provide

attribution.) Alternatively, you can sign up for a paid stock photo site such as Shutterstock or Graphicstock. The latter offers the best value for money if you sign up for the annual package. It costs around about $100 a year for unlimited downloads. Being subscribed to a paid site can also help you to see what is selling and what is trending. Add social media sharing buttons and make it easy for people to sign up for updates or for your newsletter.

Your Newsletter
There is a fine line between useful and spam. Keep the sales talk in the newsletter to a minimum. Again, your aim is to provide information that people will want to share.

Social Media
It's important to have social media pages for your business. There is an ongoing debate as to which is better for your business. You need to have a look at which social media platforms you feel most comfortable with and concentrate your efforts there. You can have more than one social media account but it pays to concentrate your efforts on just a couple.

Here are some to consider:
• **Instagram**: Instagram is great for brand-building. It is extremely popular. You cannot post links on

Instagram but its popularity with the younger generation makes it a worthwhile one to consider.

• **Pinterest**: This allows you to post just a photo. The photo can link back to your site or your blog. For a photographer, this is a good medium and does not have to take a lot of time.

• **Facebook**: Facebook allows you to set up a page for your business. It can be highly effective but getting organic traffic is becoming more difficult. Facebook prioritizes popular posts so your clients might not see your posts in their feed. You can gain more exposure but paying for Facebook Ads. They are easy to set up, inexpensive, easy to track and can be targeted as much as you like.

• **Twitter**: Twitter can drive traffic your way. Twitter is great for promoting something or doing a quick announcement. But remember, your post cannot be longer than 140 characters. You are allowed to post links.

• **YouTube**: YouTube is another good way to connect with potential clients. Again, you need to portray a professional image so make sure you have proper lighting, good sound equipment and a good video camera. Keep the videos short but informative.

These are the biggest social media sites at present. There are many others as well. The rules for social media posting are consistency and usefulness. About 80% of your posts should be completely unrelated to sales.

Social media is more about developing your brand than actually selling. You want people to want to see what your next post and not block you as spam. It's a good way to get people to go through to your blog or website.

When you place your link, most social media sites will bring up the link and pictures that are associated with it. Also, consider making videos and GIFs for your social networking sites. People today are a lot more visual. They would rather watch a video than read an article. Videos can keep them interested. Pictures are more eye-catching than a block of text so be sure to include lots of pictures. You can go to a site such as Canva to resize images or to add text easily. Canva is free to use. You can opt to upload your own images, or use theirs. Some images on the site are free, others cost $1.

Social media is also a great opportunity to let people get to know you a bit better. Throw in some personal updates as well so that they can relate to you as a

person. It is best to steer clear of politics, religion and racy jokes when sharing.

SEO

This stands for Search Engine Optimization. Basically, the higher your website/ or blog rates in search engine results, the more traffic you will get. It used to be a simple case of stuffing as many keywords as you were able to in a page. That behavior now could get you penalized by search engines. The best way to improve your SEO is to ensure that the posts are easy to scan, of high quality and relevant.
You can still use keywords but at a concentration no higher than 2%.

Posting regularly, and sharing your posts on social media are both excellent ways to drive traffic to your site.

Paid Advertising

There is no getting away from it, you will need to advertise your business. This could be by means of flyers, ads in local newspapers, online business directories and online advertising. Adwords or Bing Ads can be a cost-effective way to drive traffic to your site. Facebook ads are a less expensive way to try the waters and see what works.

With Adwords and Bing Ads, you set the amount that you will per click/ action. The problem is that you will need to ensure that your bid is attractive to the people who display the advertising. For example, you choose to pay $1 a click. If your competitors are paying $2 a click, their ads are more likely to be prioritized.
To go into a full explanation of Adwords and Bing Ads is beyond the scope of this book. Both companies provide detailed descriptions of how their programs work so it's best to visit their respective sites.

An alternative method to paid advertising, advertising on someone else's website or blog is also possible.

Consistency is the Key
All your efforts need to be consistent if you hope to succeed. You need to post to your blog when you say you will. You need to post to your social media pages when you say that you will. Throughout all your campaigns, online and offline, you need to maintain a consistent image. People need to be able to instantly recognize your brand.

Is the Advertising Working?
If you have multiple advertising methods, it can be difficult to distinguish which are performing best. Maybe they visited your site because of an ad on the paper, or maybe it was an online ad.

If you want to monitor which ad methods are most effective, consider adding a special discount code for each different type of ad. Clients who want to avail of the discount will then need to enter this code when they check out. When you tally the totals, you'll be able to see which method brought in the most business.

Creating a Buzz
You want to get clients excited about your work. You want them to feel that they are getting an exclusive deal. Don't release your photos one at a time. Group them in groups of 10 or so and create a buzz before releasing them.
This can easily be done using social media and email marketing. Allow your existing subscribers sneak on what you are offering. Consider having a pre-launch showing of your work. If you can get people excited about your new launch, they are far more likely to buy.

CHAPTER 6: WHAT SHOULD YOU SELL?

Start off deciding who your primary target market is going to be.
• Who is most likely to buy your work?
• Do you want to concentrate on high-class art photography?
• Do you want to go for volumes rather than higher prices?

Understanding Your Target Market
It's important to understand who you are going to be selling to. Afterwards, plan your strategy accordingly. You cannot target everyone and hope someone will buy. It will be a waste of time and effort. If you want to target a higher income client, for example, you need to ensure that your product looks professional and is exclusive.
After all, no art collector wants a photo that is also available on mugs, etc. But what do you do if you cannot sell high-end art straight away? You can always set up a stock photo account or third party store account in a different name. It is a bit more work but allows you to target your marketing more effectively.

Find out everything you can about your target market – where they live, shop, eat, etc. What their average age is, their income is, what programs they watch.

Anything that can give you an idea of what their lifestyles entail. Then match your advertising strategy and product line to that.

Setting Your Prices
It is good policy to have different levels of offerings for each client base that you are selling to. And you need to start getting the prices right straight away. People are willing to pay more if they see value in the purchase. Starting off at bargain prices if you are trying to attract a higher-income earner is counter-productive.

First off, the potential buyer will wonder why the work is so cheap. Second, if you want to raise your prices later, it will be harder to do. Buyers are fairly predictable when it comes to pricing. You need to have one or two items that have a high price and have two or three items that you sell at a very small markup. Everything else should be sold somewhere in between the two. This is your actual base pricing. The high-priced items are not necessarily going to sell. What will happen, though, is that the buyers will believe that they are getting a better deal when they see the moderately-priced items.

The lower-priced items are also there to make the moderately-priced items seem like a better value.

People are funny – they don't want to pay the highest price but they also don't want something they view as "cheap." Midline prices are going to be good sellers.

Your Actual Product Line
Did you know that 9 out of 10, people would buy generic item? This is especially true if they are buying gifts. As a rule of thumb, have one or two items where you let your creativity go wild and have two or three items that are on trend. The bulk of your work, however, should be of a more generic or classical nature that won't date.

Basically, black and white photos, sepia tones, etc. are classics that are always in demand. Local landmarks and dramatically beautiful photos are others that will usually do well. Having the bulk of your work in this category ensures that your work has a longer-lasting appeal. It is also easier for your client to fit in with their current style.

You do have to pay some attention to trends as well. What colors are most popular at the moment? Can you plan photo shoots around these colors? Pantone releases two colors of the year each year. Manufacturers then base their product lines on these colors. That means that décor; fashion, etc. will all have items in that color. You can add a few items that

are based on these colors so that they fit in with the most up to date décor.

Find Out What Your Competition is Doing
You don't need to emulate your competition but you can learn a lot by checking out what they are selling. Find out what they are featuring on their site. Are they doing anything that you could do better? Learn from this and adapt it to your site.

Analyzing Your Progress
So many people are afraid to admit that they made a mistake. Check what your progress has been and ditch what is not working for you. It's important to be able to course correct if you need to. There is nothing more demoralizing than sitting with stock that just isn't selling. If this goes on for months, it is an indication that you have misunderstood your market.

CHAPTER 7: MAKING MORE MONEY

The more creative you are, the more likely you are able to make more money. Look for ideas that don't cost you a lot of time or money but that increase the value of your offering to your client.

Here are some ideas that you might want to try:
- **Have an Upsell Option:** Let's go back to the photo booth idea at the fair. You can sell candid shots then upsell a nice frame to go with them. Alternatively give them the option of having it mounted on a canvas. See if they would like you to do a collage of photos.

- **Start Thinking Creatively:** You don't have to be limited to selling your photos as prints. Try some other ideas as well. Maybe mount it on a wooden block or even a metal one. You can also print your work on fabric like cushions or throw pillows. Be creative and don't limit yourself.

- **Let people See You at Work:** People are usually fascinated when they see an artist at work. Get out and about and let people watch you take photos.

- **Do Collections:** Let's say you take a family portrait. You can offer to include copies for grandparents, etc.

- **Reward Your Clients:** Show your clients that you appreciate them. Offer them discounts, free downloads, etc. If they like you and they feel that you have done them a favor, they are more likely to recommend you.

- **Have a Party:** This is a lot like a Tupperware party but you take pictures instead of selling Tupperware. You offer the host or hostess a gift for inviting guests.

- **Sell Photos in Groups:** You can put together a set of three different landscapes that look good together, frame them and package them as a deal.

- **Include Extras When Making a Sale:** These do not have to be huge. It can be as simple as a card thanking the client for the sale. Or perhaps you could include something small like a keychain. If you are doing high-end art sales, perhaps you could include a note explaining what the motivation for the photo was, where it was taken and when it was taken.

There are many different ways to make extra money when you are a photographer. Knowing your target market well will enable you to offer them a much better value proposal.

CHAPTER 8: WHAT NOT TO DO

So far, you've learned a lot of advice on what you should do. Let's go through some things you shouldn't do:

No Business Plan
A business plan gives you a clear direction for moving forward. You need to set goals in terms of income and what you want to accomplish. A business plan will give you a basic roadmap of how to do that. The business plan can evolve over time but it is a mistake not to have one.

Having No Money to Fall Back On
The idea of quitting your job may be extremely tempting. What do you do, however, if your work is not selling and you have no income? A new business is hard work. The last thing that you want to do is to have to find a job again because you are not making enough money.

It's best to put off your resignation and start your business part-time, then save as much as possible. When your side-business is going well, you can think about quitting. Please do check with your HR department if you need permission to run a business on the side.

Buying Too Much Equipment to Start With
A talented photographer will be able to work with the tools that they have. When starting out, you need a decent camera but you don't need a top of the line model. Keep the capital outlay initially low and preferably steer clear of debt early on. Buy things that you need rather than things that are nice to have. You can always get better equipment later when the business takes off. It is easy to get fixated on the tools that we have. Good tools, however, are no substitute for solid technique.

Not Asking for Help
Asking help from friends and relatives is a great way to gain more exposure. Even if all they do is share your social media posts on their networks, they will be helping you. The same goes for asking a professional in the business for tips. Most of us don't feel right asking another professional for help. You would be surprised, however, at how many people will help.

Flogging a Dead Horse
This is a business. Those beautiful landscapes are only valuable to your business if they are selling. Be prepared to look at things from a new angle. Change your product and marketing efforts if necessary. If you

are not willing to evolve as your market does, you won't be in business for long.

Charging Too Little
Market forces will put a ceiling on how much you are able to charge. At the end of the day, though, you also need to make a profit. A lot of starting photographers intentionally charge too small in order to get at least one foot through the door. But this could be problematic since they'll almost always encounter problems raising the price later on.

A better way is to get the client to feel that they are getting good value. The little extras that don't cost you much in time and effort will help your client see extra value in the work.

Not Taking Your Time into Account
You need to work out how much your monthly overheads are. You then need to work out how much you want to earn as a salary. Divide this figure by the number of hours in the month that you will work. You now have your basic rate per hour. Now, work out how much time you will need to spend on each piece. This should include the time spent getting to and from the location, the time to get the work developed, etc. Now you have a better idea of what to charge for your piece.

Diluting Your Efforts
Time is money. By trying to do too many things at once, you are going to be ineffective overall. Take your social media advertising for example. Let's say that you decide to advertise on Facebook, Twitter, Tumblr, etc. Each different avenue is going to require some time spent on your part. If you rush through them because you need to post, you are risking damaging your reputation. When you are starting out, it could be more effective to concentrate on just one social media account.

Working for Free
This is not something that you should do. You should always get something out of the deal. It need not be money but it must be worthwhile. Doing a charity shoot for free, for example, can help you get more exposure. It also shows your clients that you have a sense of community. Taking photos at someone's wedding for free is not likely to do you a whole lot of good. Friends and family can be the worst clients when it comes to this. They expect you to give them a discount all the time. You need to be firm with them. Let them know that your time is just as valuable to you and that you cannot do everything for free. If they really care about you, they will understand.

Another problem is that you get clients who are constantly looking for free work. This needs to be considered in terms of how valuable the client is to you. If they spend a lot of money with you and ask for a little extra once in a while, it might be worth it. If you do take it on, make sure it's not a project that will last for weeks or even more than a day or two. Remember, the time you spend on a free project can also be used for doing things that actually earn your business money. It is also worth noting that clients are much less likely to appreciate work that they did not have to pay for.

Not Setting Boundaries with Clients
You need to have firmly established boundaries with your clients and you need to enforce them. You need to separate your personal and professional life and you need to be strict about doing so. What could happen if you do not, is that clients will have no respect for your boundaries.

There is a definite trend these days that people want to be able to reach you whenever they want to. This is not fair to you. You could be left with no free time at all.

Going Overboard on Seasonal Items

It is true that people do spend more at certain times of the year but you cannot base your whole business strategy around seasonal items. What happens if the holidays are over and you have excess stock that has now become dated? You could hold it over for next year but that is going mean finding storage space for it. And what if it's not in fashion by then?

If you are going to try seasonal items, it would a good idea to stick to gift items on sites like Zazzle and CafePress that are produced on demand. Or to offer digital downloads. Try not to spend too much capital on seasonal items and remember that advertising starts a few months before, not a few days before the holiday.

Not Having a Plan to Deal with Complaints
Things are bound to go wrong at some stage. Mistakes do happen, and if you deal with them properly, you can win the customer over. Have a plan in place to deal with complaints and mistakes. What happens if you send the wrong photo? What happens if the photo is damaged when it arrives? Knowing what you will do in these situations allows you to act quickly should the need arise.

It is important to apologize to the customer for what happened. If you were not at fault, you need to at least

acknowledge their feelings before responding defensively.

Offer a money-back guarantee and stick to your word. If a client is not happy, it is better that they can return the item and get a replacement or refund than risking a dreadful review.

Again, you need to leave your own emotions out of it. People can be unreasonable. They don't always read terms and conditions and they have their own expectations.

Avoid getting into a social media war with the person. Always treat them with respect, even if they don't do the same.

Don't Skimp on Packaging

This is one of the biggest mistakes that online businesses make. Skimping on packaging may save you some money now but it can cost you a lot in damaged merchandise. It could also negatively impact your reputation.

Have a look at how you package your photos. Are they properly protected? A sheet of acid-proof paper on the front and back of the photo will protect it from dirt. Adding a piece of sturdy card will prevent the photo from being bent. Placing everything into a plastic bag and securing it so that the card does not shift, provides

further protection. For an added layer of protection, place in a bubble wrap-lined envelope.

This sounds like a lot of work but it is necessary. Imagine if you ordered a piece of art online. You are excited to be getting it, looking forward to seeing it in person.
Now imagine that it arrives bent, scratched or torn. How disappointed and angry would you be?

Not Offering a Quality Product
If you want to sell your photos as fine art, you need to have them printed professionally. Printing them on your home printer is not going to cut it on this one. You need to ensure that the print is as true to the original as possible. If the work is displayed online, try to match the colors as closely as possible to the original.

CONCLUSION

What is left now is for you to choose the path that suits you best and to start making money with your photography. Take a good look at the time you have available to devote to this. Brainstorm extra ways to make money with your photography, then do your research. The better your research, the more successful you will be.

Write a business plan, or get someone to help you with one. Start identifying your best photos and see whether or not they fit the criteria for stock photo sites. Above all, never stop learning. Sign up for a business course if need be, read as much about the photography business. Finally, get out there, start your business and make it a success!

THANKS FOR READING

We really hope you enjoyed this book. If you found this material helpful feel free to share it with friends. You can also help others find it by leaving a review where you purchased the book. Your feedback will help us continue to write books you love.

The Smart Reads library is growing by the day! Make sure and check out the other wonderful books in our catalog. We would love to hear which books are your favorites.

Visit:
www.smartreads.co/freebooks
to receive Smart Reads books for FREE

Check us out on Instagram:
www.instagram.com/smart_readers
@smart_readers

Don't forget your 2 FREE audiobooks.
Use this link www.audibletrial.com/Travis to claim your 2 FREE Books.

SMART READS ORIGINS

Smart Reads was born out of the desire to find the best information fast without having to wade through the sheer volume of fluff available online. Smart Reads combs through massive amounts of knowledge compiles the best into quick to read books on a variety of subjects.

We consider ourselves Smart Readers, not dummies. We know reading is smart. We're self taught. We like to learn a TON about a WIDE variety of topics. We have developed a love for books and we find intelligence attractive.

We found that each new topic we tried to learn about started with the challenge of finding the pieces of the puzzle that mattered most. It becomes a treasure hunt rather than an education.

Smart Reads wants to find the best of the best information for you. To condense it into a package that you can consume in an hour or less. So you can read more books about more topics in less time.

OUR MISSION

Smart Reads aims to accelerate the availability of useful information and will publish a high quality book on every major topic on amazon.

Smart Reads hopes to remove barriers to sharing by taking the copyright off everything we publish and donating it to the public domain. We hope other publishers and authors will follow our example.

Our goal is to donate $1,000,000 or more by 2020 to build over 2,000 schools by giving 5% of our net profit to Pencils of Promise.

We want to restore forests around the globe by planting a tree for every 10 physical books we sell and hope to plant over 100,000 trees by 2020.

Doesn't it feel good knowing that by educating yourself you are helping the world be a better place? We think so too…

Thanks for helping us help the world. You Smart Reader you…

Travis and the Smart Reads Team

WHY I STARTED SMART READS

Every time I wanted to learn about something new I'd have to buy 20 books on the topic and spend way too long sorting through them and reading them all until I arrived at the big picture. Until I had enough perspectives to know who was just guessing, who was uninformed and who had stumbled upon something remarkable.

I wished someone else could just go in and figure that out for me and tell me what matters. That's how smart reads was born. I want smart reads to be a company that does all that research up front. Sorts through all the content that is available on each topic and pulls out the most up to date complete understanding, then have people smarter than me package the best wisdom in an easy to understand way in the least amount of words possible.

For example, I got a new puppy so I wanted to learn about dog training. I bought 14 different books about dog training and by the time I got through the first 5 and finally started getting the big picture on the best way to train my puppy she had grown up into a dog.

Yeah she's well behaved. She doesn't poop in the house. I can get her to sit and come when I call. But what if someone else went in and read all those books for me, found the underlying themes and picked out the best information that would give me the big picture and get me right to the point. And I'd only have to read one book instead of 15.

That would be amazing. I would save time. And maybe my dog would be rolling over, cleaning up after my kids and doing the dishes by now. That my friend, is the reason I started smart reads. Because I wanted a company I can trust to deliver me the best information in an easy to understand way that I can digest in under an hour. Because dog training is one of many subjects I want to master.

The quicker I can learn a wide variety of topics the sooner that information can begin playing a role in shaping my future. And none of us knows how long that future will be. So why not do everything we can to make the best of it and consume a ton of knowledge. And I figured all the better if I can also make a positive difference in the world.

That's why we're also building schools, planting trees and challenging ideas about copyright's place in today's world. Because as a company we have to be doing everything we can to support the ecosystem that gives us all these beautiful places to read our books. Thanks for reading.

Travis

Customers Who Bought This Customers Who Bought This Book Also Bought

The Everything Store Sales Guide: How to Make Money with Amazon FBA

Blockchain Revolution: Understanding the Internet of Money

Passive Income: Do What You Want When You Want and Make Money While You Sleep

Understanding Affiliate Marketing: An Internet Marketing Guide for How To Make Money Online Using Products, Websites and Services

Success Principles: Techniques for Positive Thinking, Self Love and Developing a Powerful

Develop Self-Discipline: Daily Habit to Make Self Confidence and Will Power Automatic

Unlocking Potential - Master the Laws of Leadership

Reinvent Yourself: Become Instantly Likable, Captivate Anyone in Seconds and Always Know What To Say

Self-Esteem Supercharger: Build Self Worth and Find Your Inner Confidence

www.ingramcontent.com/pod-product-compliance
Lightning Source LLC
Chambersburg PA
CBHW061446180526
45170CB00004B/1587